A Field Guide
to

REDHEADS

A Field Guide
— to —
REDHEADS

= AN ILLUSTRATED CELEBRATION =

ELIZABETH
GRAEBER

Workman Publishing · New York

ISBN 978-0-7611-8573-4

Book design by Becky Terhune

Ginger Carrot Soup recipe on page 21 adapted from *Food to Live By*
Chewy Gingersnaps recipe on page 45 adapted from *Cookie Swap!*

Workman books are available at special discounts when purchased in bulk for premiums
and sales promotions as well as for fund-raising or educational use. Special editions or
book excerpts can also be created to specification. For details, contact the Special Sales
Director at the address below, or send an email to specialmarkets@workman.com.

Workman Publishing Co., Inc.
225 Varick Street
New York, NY 10014-4381

workman.com

WORKMAN is a registered trademark of Workman Publishing Co., Inc.

Printed in China
First printing August 2016

10 9 8 7 6 5 4 3 2 1

to my Mom and Dad

Thank You

To my family and friends
and especially Grant for helping me.
To the inspiring redheads in this book
and to the lovely people at Workman.

Adele

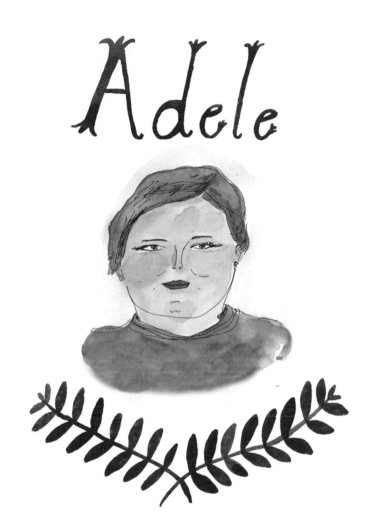

According to British *Glamour*, Adele once
had a crush on Prince Harry (see page 117).

"Red Hair is my Lifelong Sorrow."

—Anne Shirley, *Anne of Green Gables*
by Lucy Maud Montgomery

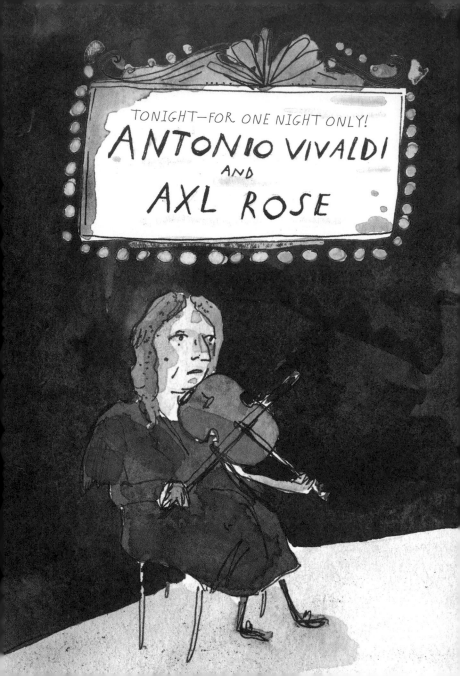

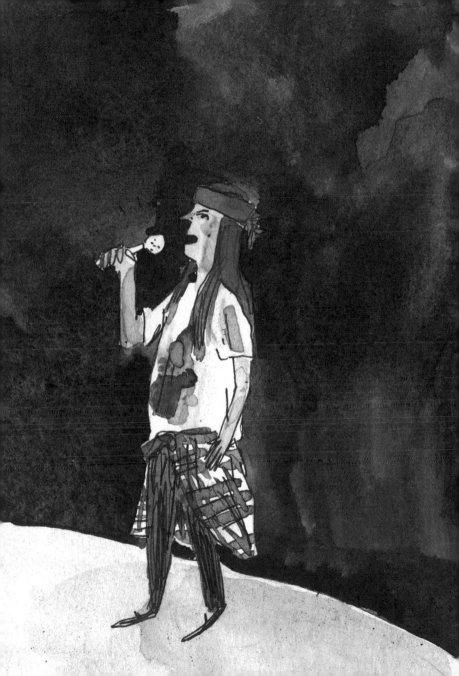

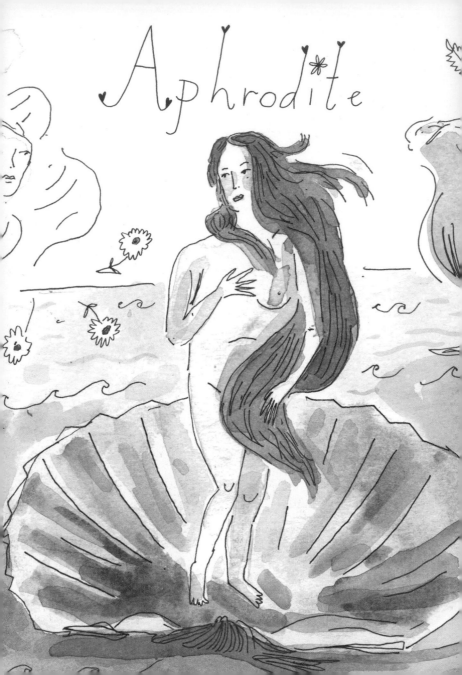

IT IS SAID THAT

Redheads

ARE MORE SUSCEPTIBLE TO

PAIN

and thus require

MORE ANESTHESIA.

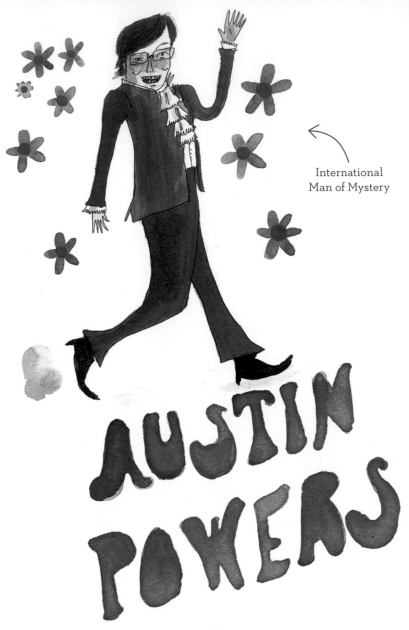

International
Man of Mystery

AUSTIN
POWERS

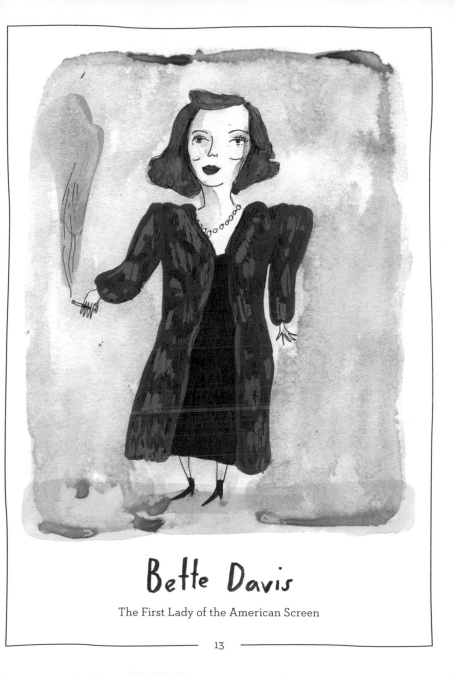

Bette Davis

The First Lady of the American Screen

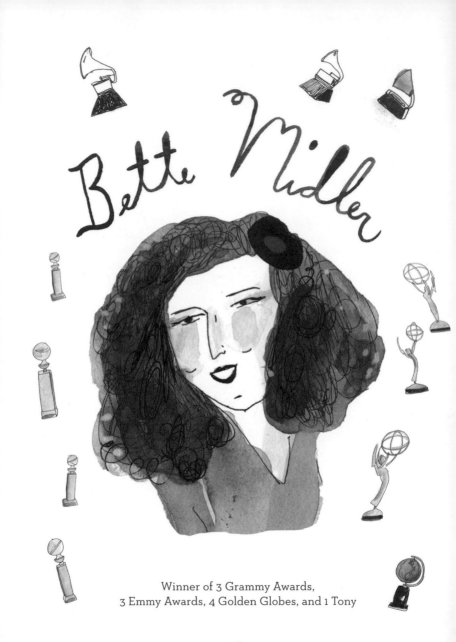

Bette Midler

Winner of 3 Grammy Awards,
3 Emmy Awards, 4 Golden Globes, and 1 Tony

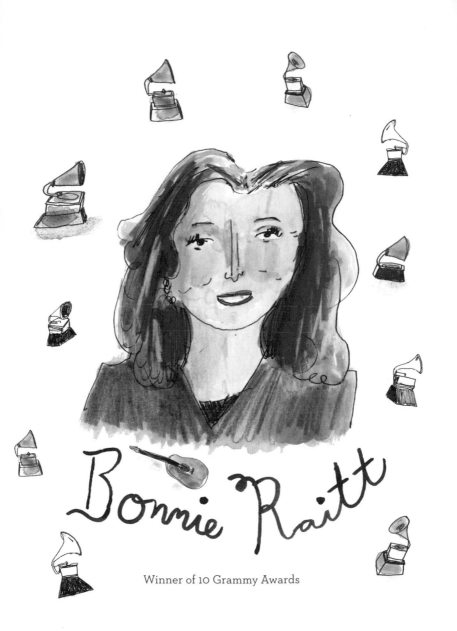

Winner of 10 Grammy Awards

The many faces of

Carol Burnett

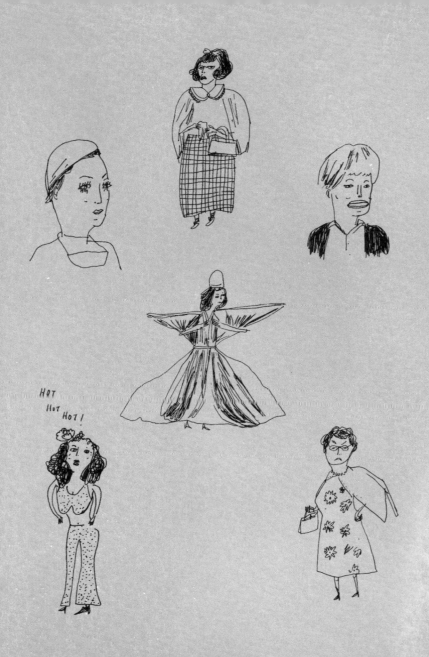

HOT
HOT HOT!

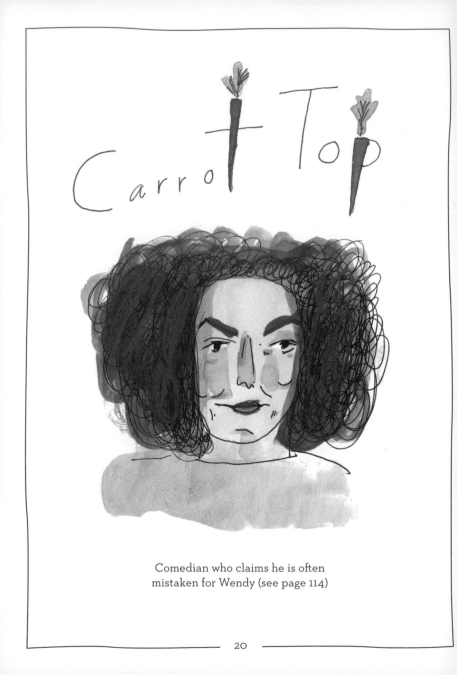

Carrot Top

Comedian who claims he is often
mistaken for Wendy (see page 114)

GINGER CARROT SOUP

Serves 4

2 tablespoons canola oil or olive oil
1 small yellow onion, coarsely chopped
1 piece (3 inches long) fresh ginger,
 peeled and coarsely chopped
1¼ pounds carrots, sliced ¼-inch
 thick
About 5 cups vegetable broth

½ cup fresh orange juice
Pinch of ground nutmeg
Coarse salt and freshly ground
 black pepper
Crème fraîche or sour cream, for
 garnish

1. Heat the oil in a large
 saucepan over medium heat.
 Add the onion and ginger and
 cook, stirring occasionally,
 until soft, about 5 minutes.

2. Add the carrots, broth, and
 orange juice. Increase the
 heat to medium-high and
 bring to a boil. Reduce the
 heat to low, cover, and let
 simmer until the carrots
 are very tender, about 45
 minutes.

3. Let the soup cool slightly,
 then puree it in a blender or
 food processor. If you prefer
 a smoother texture, strain the
 pureed soup through a sieve.

If the soup is too thick, thin
it with some water or more
broth.

4. Add the nutmeg to the soup
 and season it with salt and
 pepper to taste.

5. To serve the soup warm,
 reheat it gently over
 medium-low heat. To
 serve the soup chilled,
 refrigerate it, covered,
 until cold, at least 6 hours
 or up to 5 days. Garnish
 the soup with a spoonful
 of crème fraîche before
 serving.

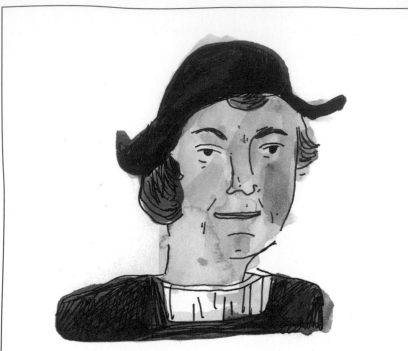

Christopher Columbus

Big proponent of Earth roundness

Redheads Around the World

2 to 6% of Americans have red hair (including at least one fictional Scottish-born groundskeeper).

10% of Ireland's population is redheaded.

Redheads make up 6% of England's population.

13% of Scots are redheaded.

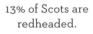

Red hair is most common in people of northern or western European ancestry (2 to 6%).

A TALE OF

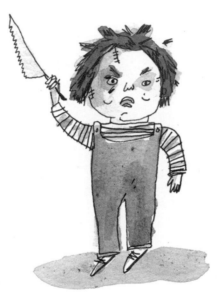

Chucky

(aka Charles Lee Ray)
Husband and father
Carries a knife
Terrifying

TWO CHUCKIES

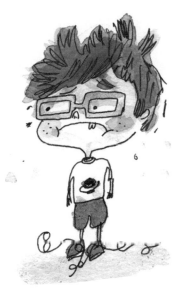

Chuckie

(aka Charles Crandall Norbert "Chuckie" Finster Jr.)
Awkward child
Shoes always untied
Terrified

Clara Bow

Silent film actress and original "It Girl," thanks to her
starring role in the wildly popular 1920s film *It*

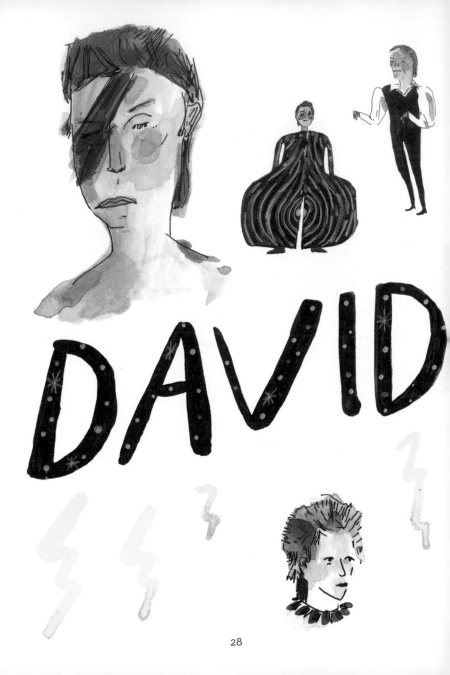

DAVID

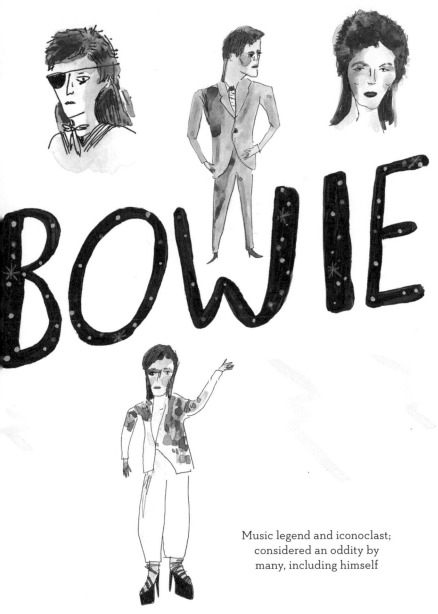

BOWIE

Music legend and iconoclast;
considered an oddity by
many, including himself

Flannel Moth Caterpillar

This poisonous caterpillar is nicknamed the
"Donald Trump Caterpillar" for its uncanny
resemblance to The Donald's "hair."

← Toupée? Real hair?
Caterpillar? No one
will ever know . . .

Donald Trump

In the 16th century, the fat of a redheaded man was an important ingredient in poison.

Dorothy & Glinda

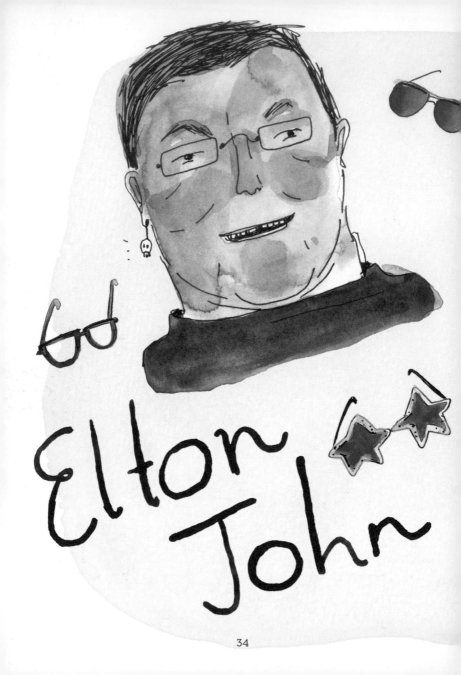

Elton John

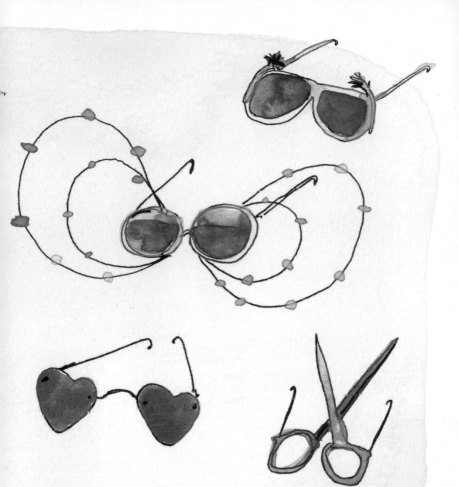

Singer-songwriter and avid
eyewear collector, he owns more
than 250,000 pairs of glasses.

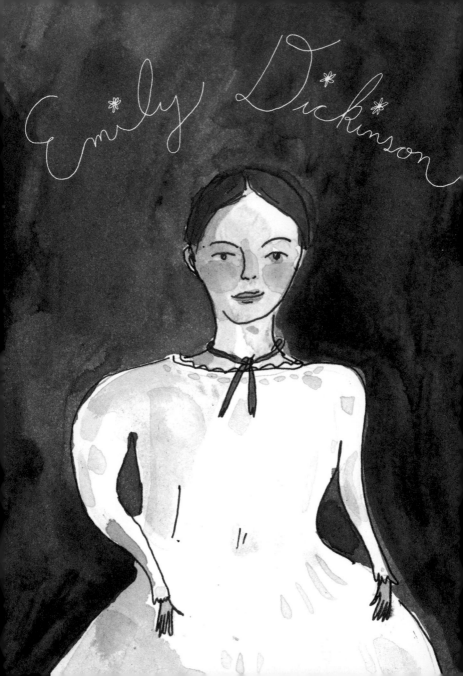

Wild nights - Wild nights!

Wild nights - Wild nights!
Were I with thee
Wild nights should be
Our luxury!

Futile - the winds -
To a Heart in port -
Done with the Compass -
Done with the Chart!

Rowing in Eden -
Ah - the Sea!
Might I but moor - tonight -
In thee!

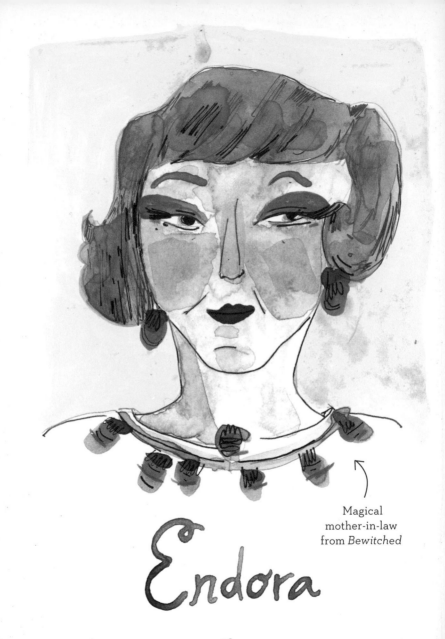

Magical
mother-in-law
from *Bewitched*

Endora

Erik the Red

Icelandic explorer, founder of the first
Norse settlement in Greenland

FAST REDS

Carlos Valderrama
Plays soccer with "electric" feet

Lightning McQueen
Rules the raceway

Mario Batali
Fast-chops in his Crocs

Chuck Norris
Performs quick karate moves

Meteor
Travels near the
speed of light

Miss Frizzle

Drives a speedy shape-shifting school bus

Foods, Red

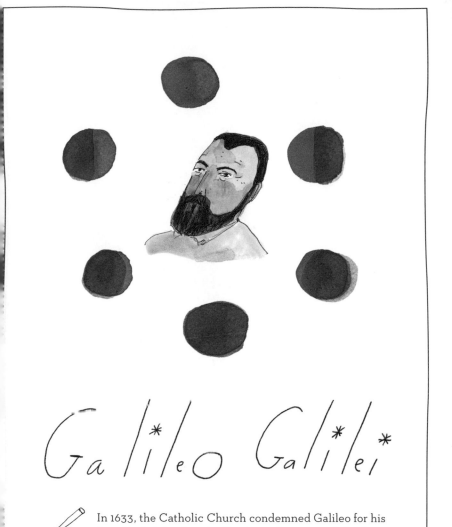

Galileo Galilei

In 1633, the Catholic Church condemned Galileo for his heretical claim that the Earth revolves around the Sun. Galileo was forced to recant his discoveries and spent the rest of his life under house arrest. It took the Church more than 300 years to admit its mistake and clear Galileo's name.

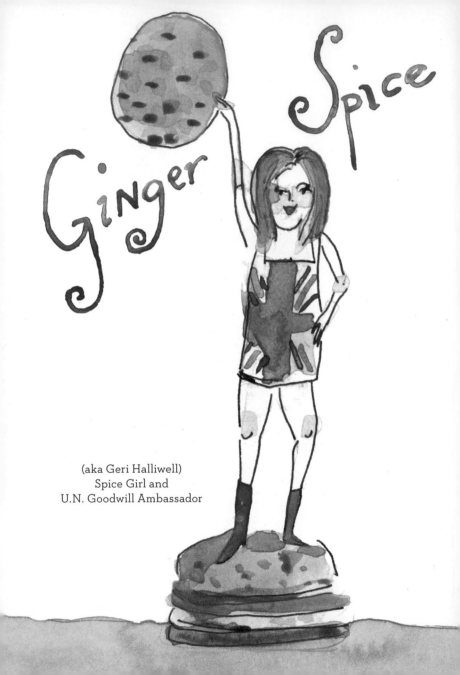

Ginger Spice

(aka Geri Halliwell)
Spice Girl and
U.N. Goodwill Ambassador

CHEWY GINGERSNAPS

Makes 36 cookies

2 cups unbleached all-purpose flour
1½ teaspoons ground ginger
½ teaspoon ground cinnamon
¼ teaspoon ground cloves
½ teaspoon salt
½ teaspoon baking soda

¾ cup (1½ sticks) unsalted butter, melted and cooled
1 cup sugar
¼ cup dark molasses
2 large eggs

1. Preheat the oven to 350°F. Line several baking sheets with parchment paper.

2. Combine the flour, ginger, cinnamon, cloves, salt, and baking soda in a medium-size bowl.

3. Place the butter, sugar, and molasses in a large bowl and stir together with a wooden spoon until smooth. Add the eggs and beat with an electric mixer on low until smooth. Stir in the flour mixture until just incorporated. Place the bowl in the refrigerator, uncovered, to let the dough firm up, about 10 minutes.

4. Drop the batter by tablespoonfuls 2 inches apart on the baking sheets.

5. Bake the cookies until they are firm around the edges but still soft on top, about 10 minutes. Let them stand on the baking sheets for 5 minutes, and then slide the parchment with the cookies to a wire rack to cool completely.

Chewy Gingersnaps will keep in an airtight container at room temperature for 3 days.

GRACE CODDINGTON

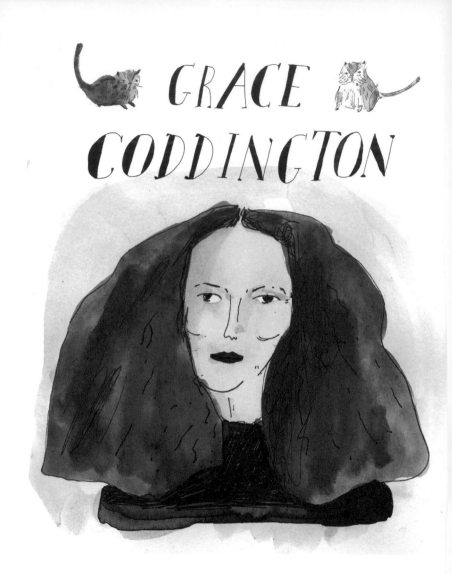

Former creative director of *Vogue*
and ardent cat lover

Greer Garson

Set the record for the longest Oscar acceptance speech,
clocking in at five-and-a-half minutes

Heat Miser

Nemesis (and half-brother) of Snow Miser;
makes life difficult for Santa Claus

Helen of Troy

The face that launched a
thousand ships

Henri Matisse

Known for his cut-paper collages, which he
referred to as "painting with scissors"

"If he were a painter he would paint her in that attitude. Her blue felt hat would show off the bronze of her hair against the darkness and the dark panels of her skirt would show off the light ones. *Distant Music* he would call the piece if he were a painter."

— James Joyce

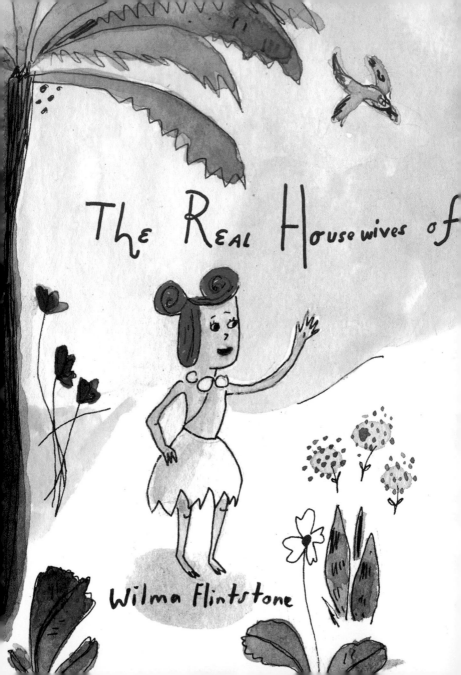

Hanna-Barbera

Jane Jetson

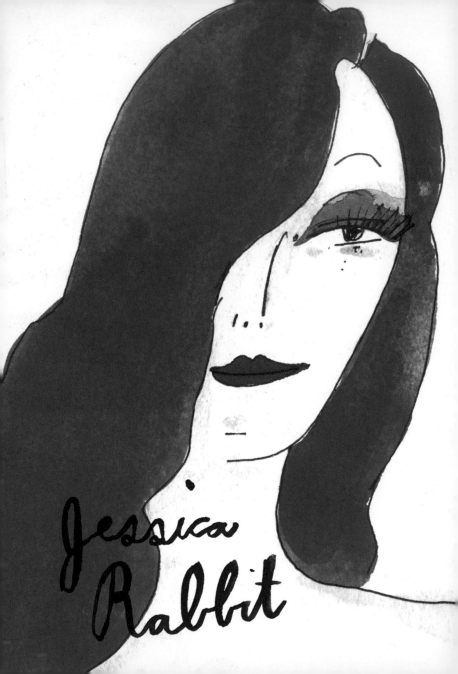

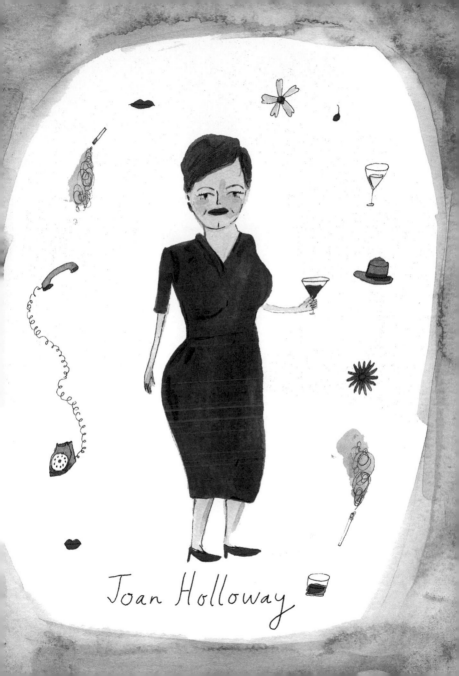

Joan Holloway

Joanna of Castile

aka Joanna the Mad, Queen of Castile and Aragon

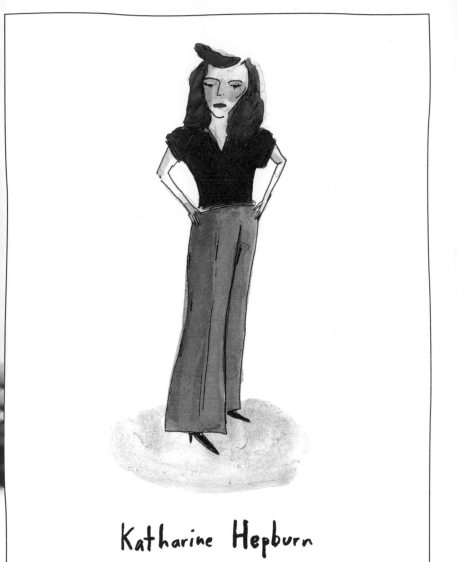

Katharine Hepburn

Legendary actress and early adopter of pants

Little Orphan

Annie

Lizzie Borden

As a young woman in 1892, Lizzie was accused of the double ax murders of her father and stepmother. She was never found guilty but was the only suspect in the crime.

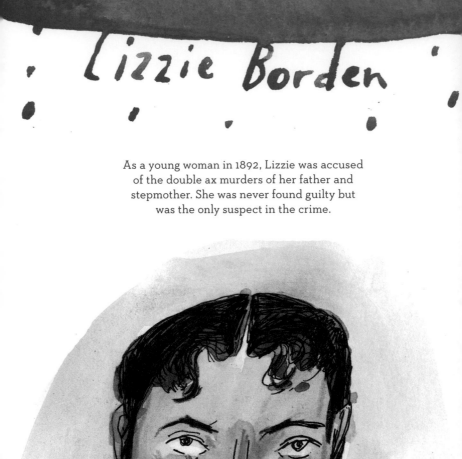

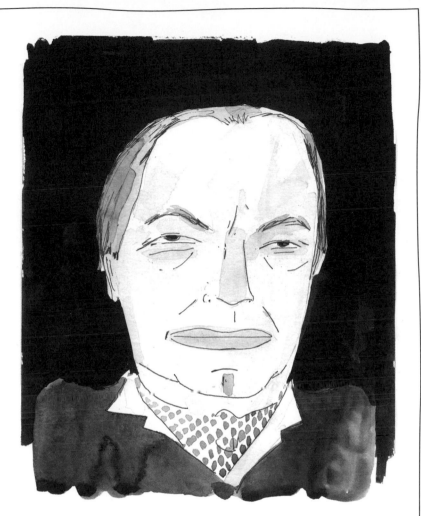

L. Ron Hubbard

Founder of the Church of Scientology, thought to be orbiting
his own planet out in space somewhere

The MC1R (melanocortin-1 receptor) gene is what determines hair color. For people with blond, **brown**, or **black** hair, the gene produces melanin. **Red** hair is the result of a recessive variation in the gene that produces pheomelanin instead.

RED is the world's rarest hair color.
Other rare things:

A double rainbow

Leap day

A 1918 United States "Inverted Jenny" stamp

The Corpse Flower, which grows 10 to 20 feet tall, blooms every 7 to 10 years, and smells like rotting meat

A four-leaf clover

A gold-filled treasure chest

Bigfoot

"Nessie" aka the Loch Ness Monster

A blue-eyed albino alligator

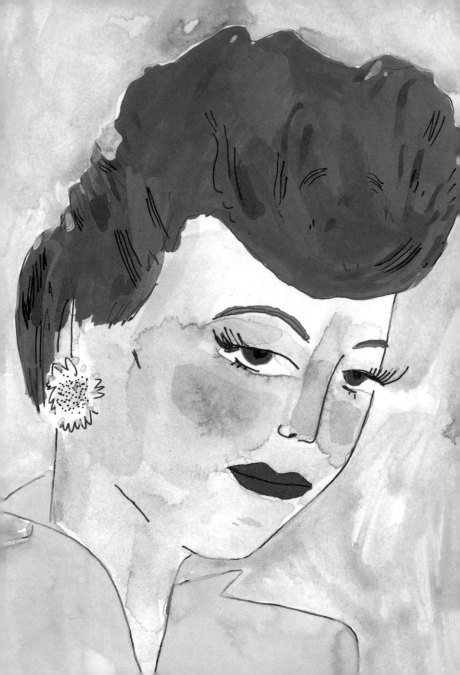

"Once in his life, every man is entitled to fall madly in love with a gorgeous redhead."

— LUCILLE BALL

Lynette "Squeaky" Fromme

Member of the Charles Manson family,
tried to assassinate President
Gerald Ford in 1975

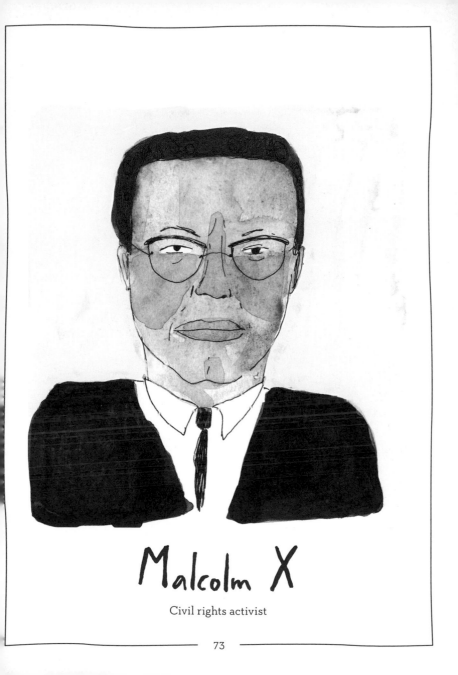

Malcolm X

Civil rights activist

"WHILE THE REST OF THE SPECIES IS DESCENDED FROM APES, REDHEADS ARE DESCENDED FROM CATS."

-Mark Twain

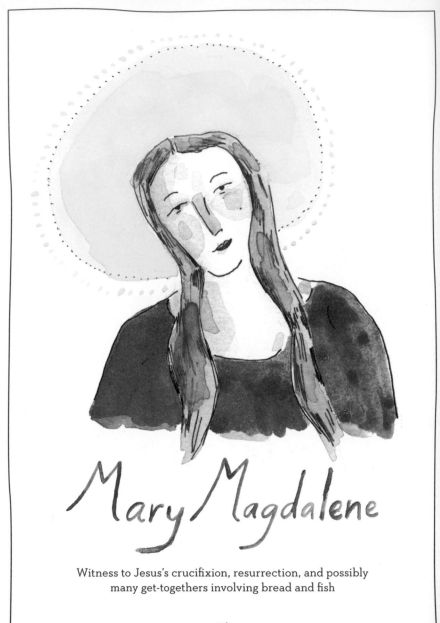

Mary Magdalene

Witness to Jesus's crucifixion, resurrection, and possibly
many get-togethers involving bread and fish

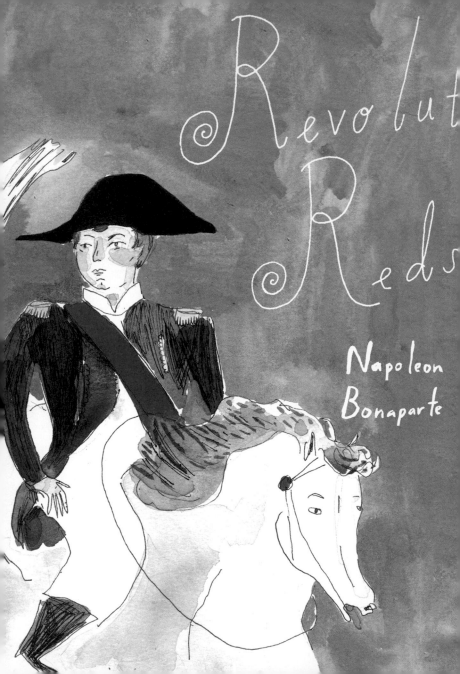

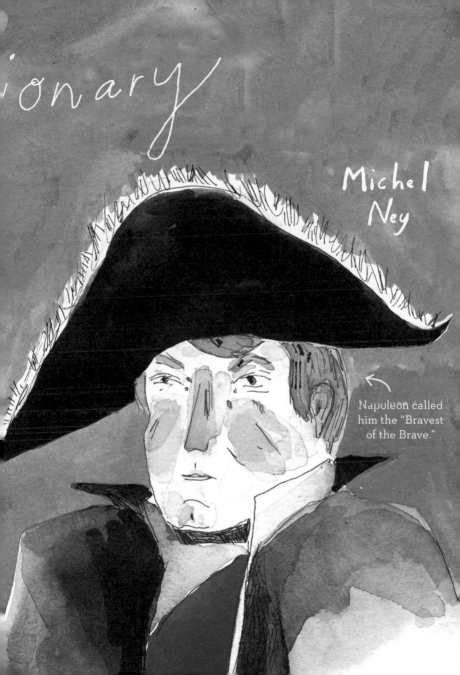

ionary

Michel Ney

Napoleon called him the "Bravest of the Brave."

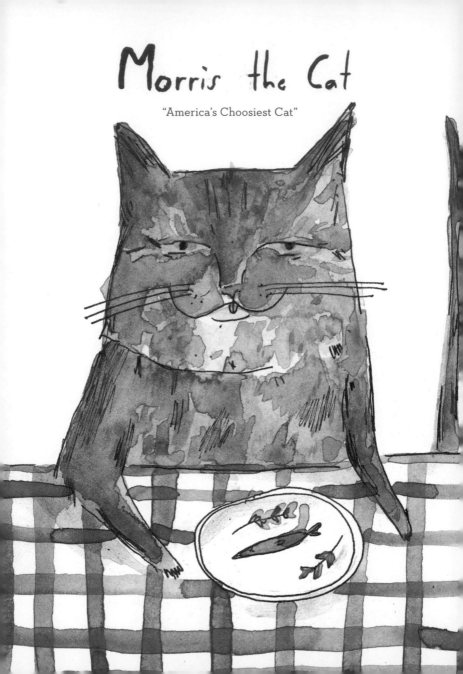

Morris the Cat

"America's Choosiest Cat"

MUPPETS EN ROUGE

Name: Elmo
Works for: Sesame Street
Catchphrase: "Elmo loves you!"

Name: Beaker
Works for: Dr. Bunson Honeydew
Catchphrase: "Mee-mee-mee-mee!"

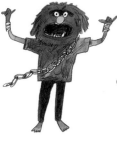

Name: Animal
Works for: Dr. Teeth and
the Electric Mayhem
Catchphrase: "Beat drums! Beat drums!"

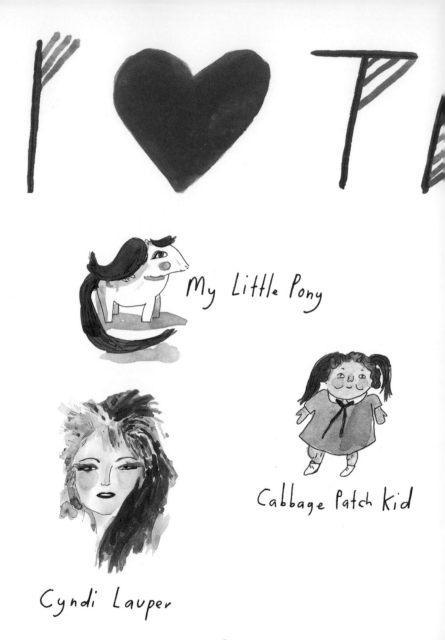

My Little Pony

Cabbage Patch Kid

Cyndi Lauper

 '80s

The Brat Pack

Eric Stoltz

Anthony Michael Hall

Molly Ringwald

Nell Gwyn

"Pretty, witty Nell,"
mistress of King Charles II

Redheads are more likely to be left-handed.

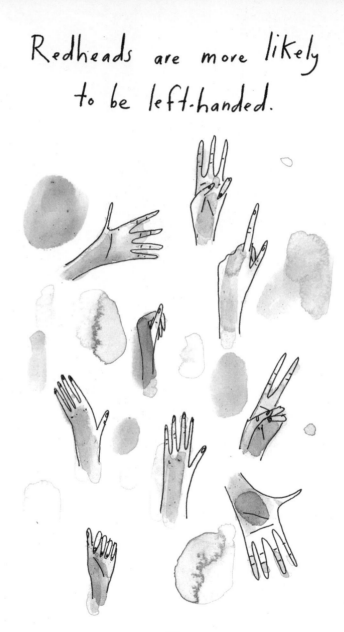

PALE FORCE
& FRIENDS

Conan O'Brien

Jim Gaffigan

Louis C.K.

Pale
Male

Red-tailed hawk,
New York City's most
famous avian dweller

EVERYDAY REDS

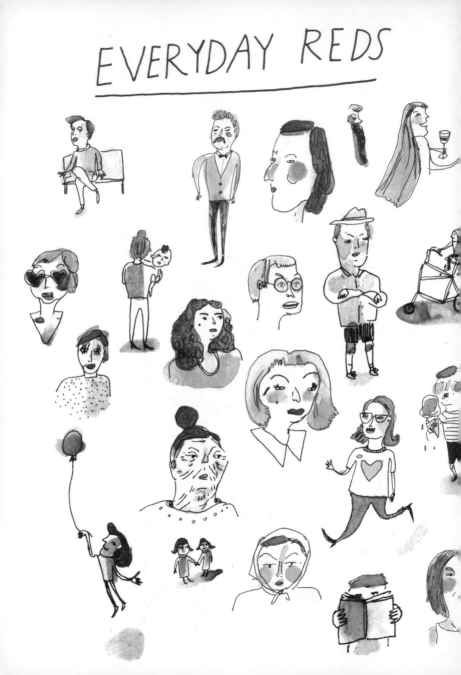

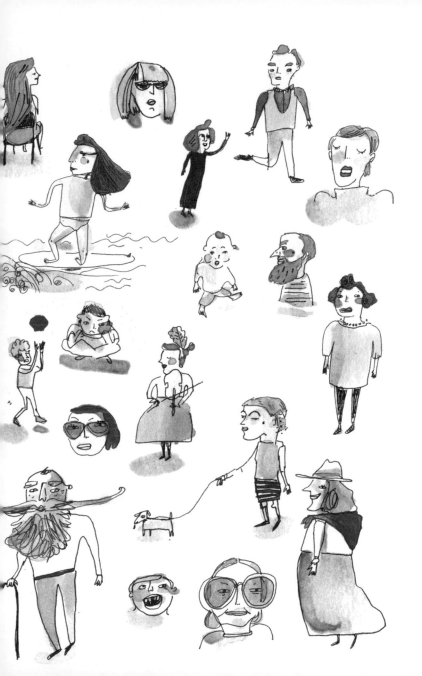

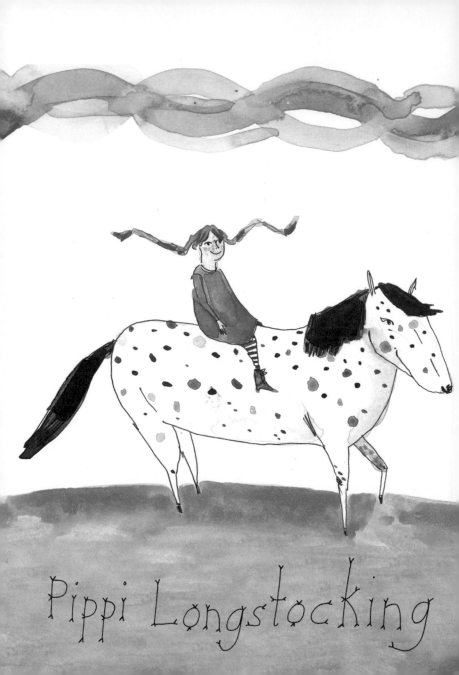

Pippi Longstocking

HOW TO MAKE PIPPI BRAIDS

You will need:
long red hair
1 hairbrush
4 hair ties
2 pipe cleaners
4 decorative ribbons

1. Brush your hair and part it in the middle.

2. Separate your hair into two pigtails and secure each with a hair tie.

pipe cleaner →

3. Place a pipe cleaner in the center of each pigtail and braid the hair around it. Secure each end with a hair tie.

4. Mold the braids horizontally and tie a ribbon at the beginning and end of each braid.

A Day at the beach

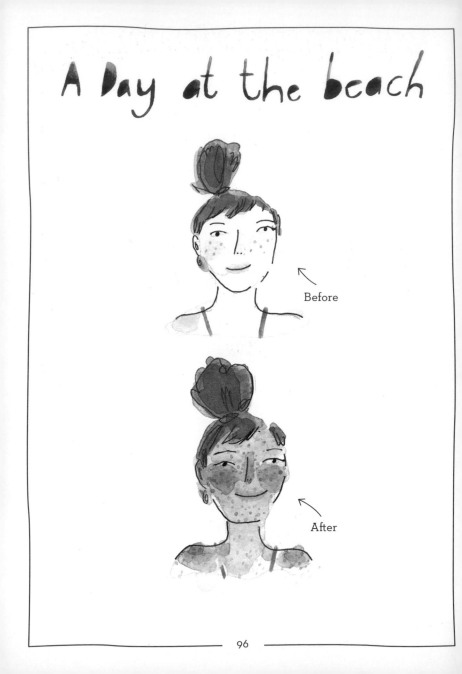

Before

After

Redheads of

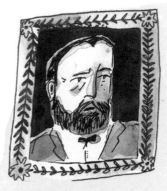

Ulysses S. Grant
1869–1877

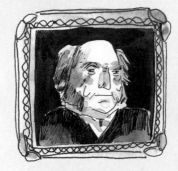

Martin Van Buren
1837–1841

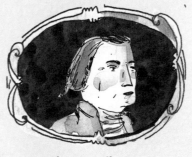

Thomas Jefferson
1801–1809

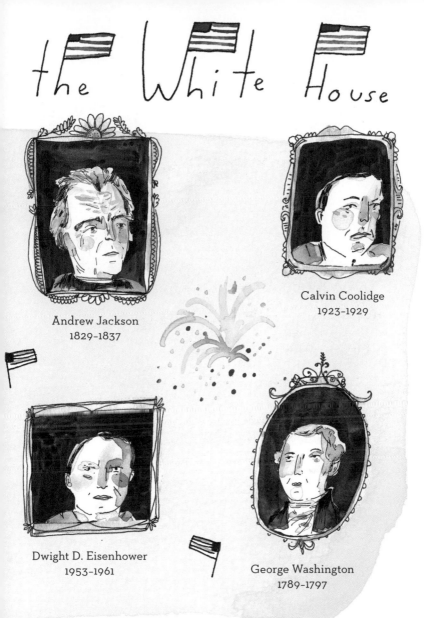

the White House

Andrew Jackson
1829–1837

Calvin Coolidge
1923–1929

Dwight D. Eisenhower
1953–1961

George Washington
1789–1797

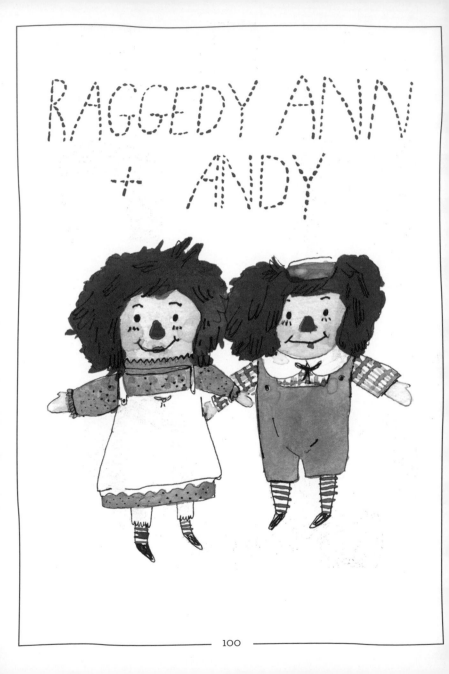

RED CARPET REDS

Damian Lewis

Julianne Moore

Emma Stone

Cynthia Nixon

Debra Messing

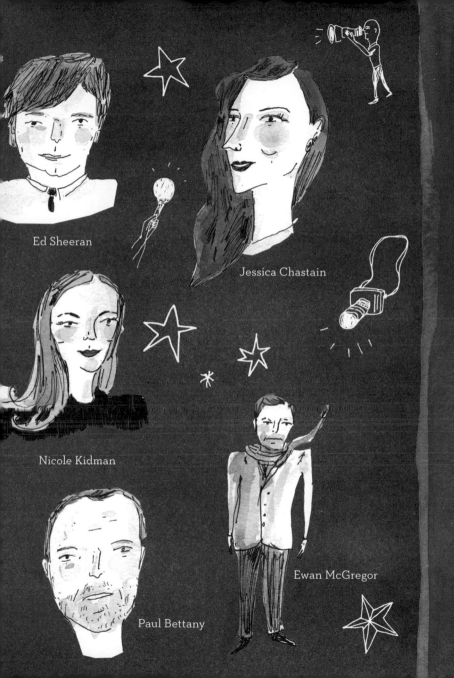

Ed Sheeran

Jessica Chastain

Nicole Kidman

Paul Bettany

Ewan McGregor

Red Skelton

Entertainer, radio star,
and television host

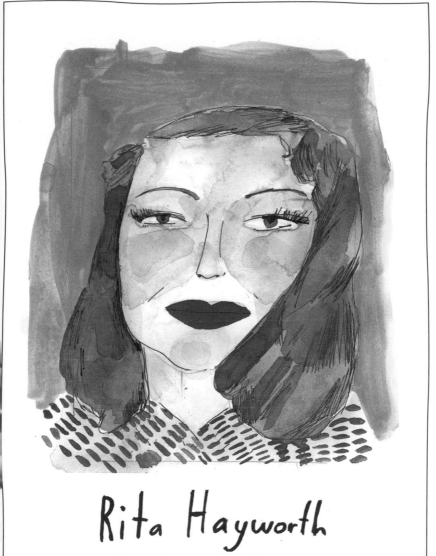

Rita Hayworth

Actress, dancer, and popular pinup

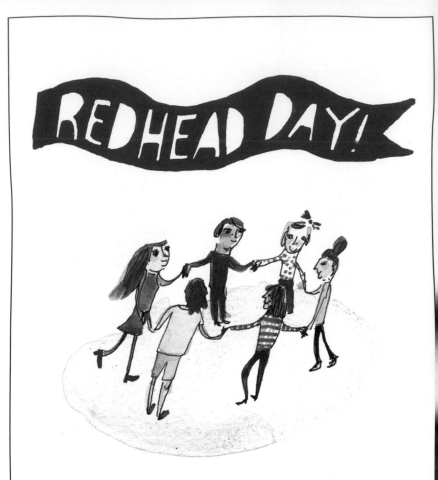

REDHEAD DAY!

A three-day festival in Breda, Netherlands, that celebrates people with natural red hair. Activities include workshops, demonstrations, lectures, art, and music.

Other redhead
celebrations
around the world:

Irish Redhead Convention
Cork, Ireland

RossItalia
Milan, Italy

Redhead Event
Portland, Oregon, USA

Ginger Pride Walk
Rome, Georgia, USA

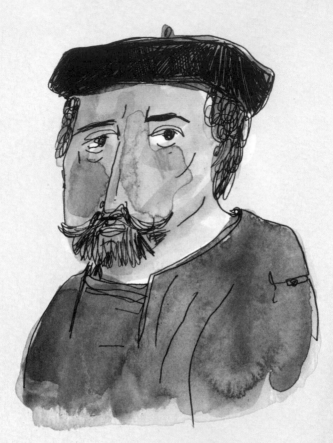

Rob Roy

Highland outlaw known as
the Scottish Robin Hood

ROB ROY

Makes 1 drink

2 ounces blended Scotch whiskey

¾ ounce sweet vermouth

1 dash of Angostura or orange bitters

Cherry or lemon twist, for garnish

1. Place the whiskey, vermouth, and bitters in a cocktail shaker.

2. Add cracked ice and shake well.

3. Strain into a chilled cocktail glass. Garnish with the cherry.

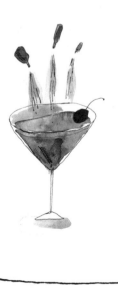

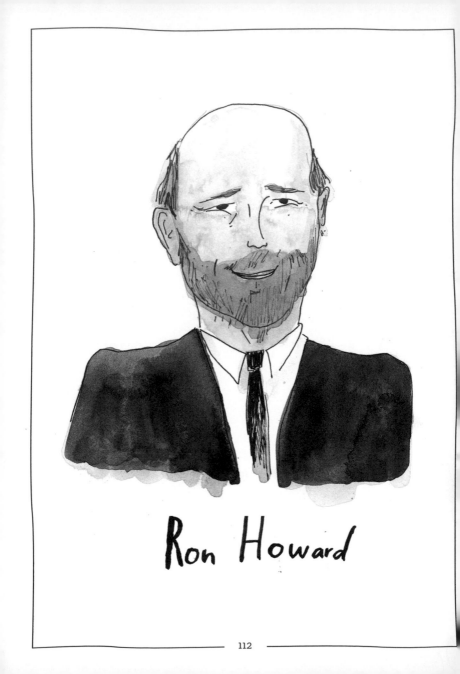

Ron Howard

RONALD & WENDY
dancing at the French Fry Disco

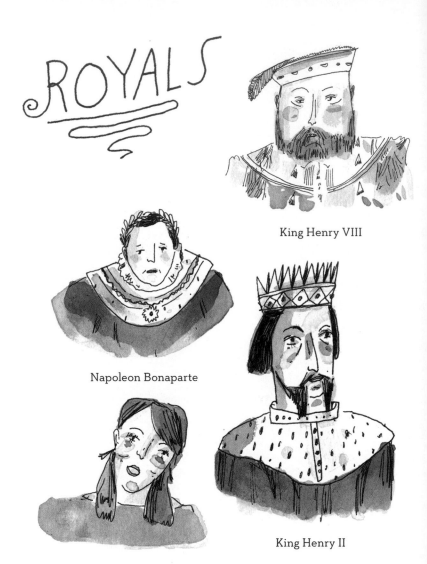

ROYALS

King Henry VIII

Napoleon Bonaparte

King Henry II

Sarah Ferguson

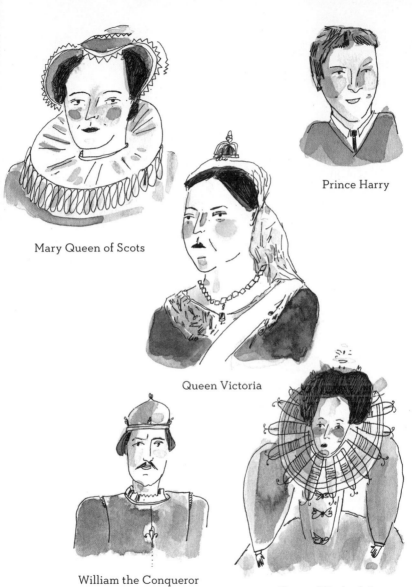

Mary Queen of Scots

Prince Harry

Queen Victoria

William the Conqueror

Queen Elizabeth I

Rurik

Norse leader

MISSING

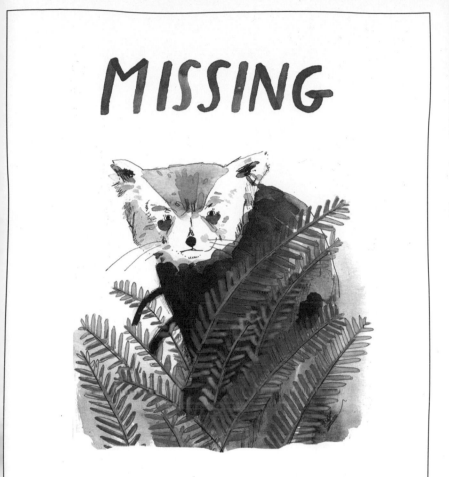

Rusty the Red Panda

In 2013, Rusty ran away from the National Zoo.
He was later found wandering the Adams Morgan
neighborhood of Washington, D.C. When asked what
prompted his escape, Rusty had no comment.

Scully

FBI agent on *The X Files*
Reason to Mulder's Passion—and eventually, Mulder's passion

THE ANCIENT GREEKS BELIEVED
THAT REDHEADS TURNED INTO
VAMPIRES WHEN THEY DIED.

The Many Faces of Tilda Swinton

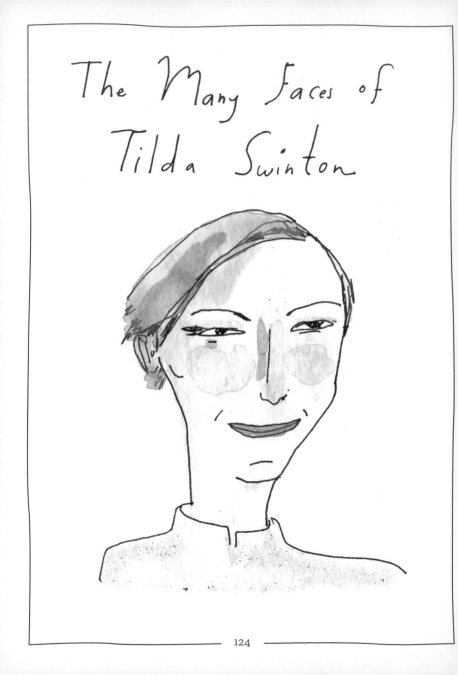

Some people think she
looks like David Bowie
(see pages 28–29).

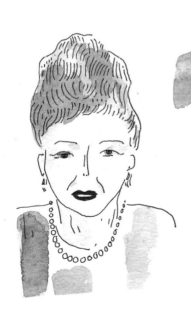

Shaun White

Professional snowboarder,
aka "The Flying Tomato"

GINGERPHOBIA

a fear of redheads

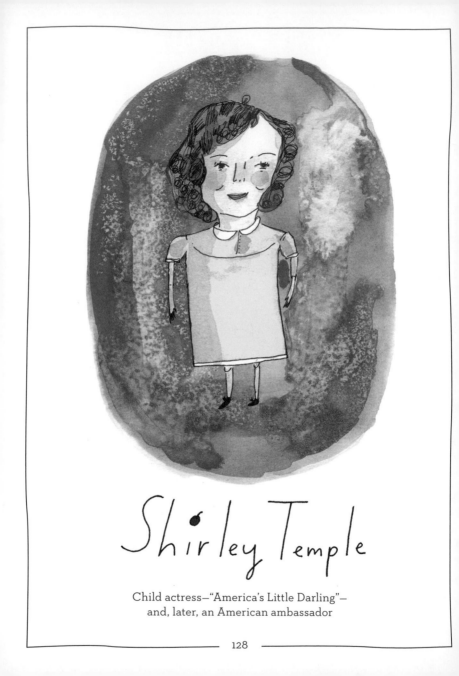

Shirley Temple

Child actress—"America's Little Darling"—
and, later, an American ambassador

SHIRLEY TEMPLE

Although the Shirley Temple mocktail took its name from the actress, the actress was never a fan of the drink, saying it was too sweet for her taste.

Makes 1 drink

Splash of grenadine
Ginger ale
1 maraschino cherry

1. Place the grenadine in a Collins glass and fill with ice.
2. Top with ginger ale and stir gently. Garnish with the cherry.

Sissy Spacek

Strawberry
Shortcake

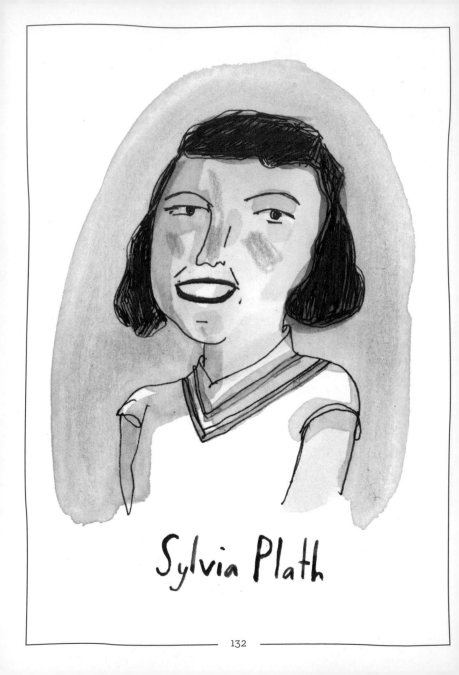

Sylvia Plath

"I took a deep breath
and listened to the old
brag of my heart.
I am, I am, I am."

— The Bell Jar

Some believe that the color TITIAN RED derives its name from the Italian Renaissance artist Titian (Tiziano Vecellio), who painted many redheads.

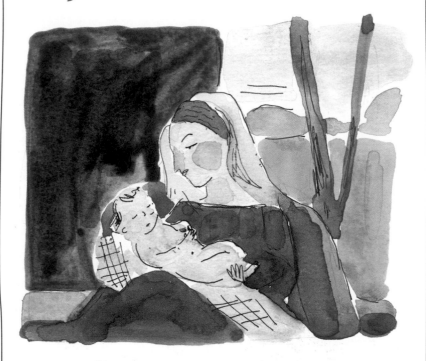

Titian, *Madonna and Child*, 1510

Popular Natural Red "HAIR DYES"

BEETS

TOMATOES

FLOWERS

HENNA

PAPRIKA

red mountains

Thelma & Louise

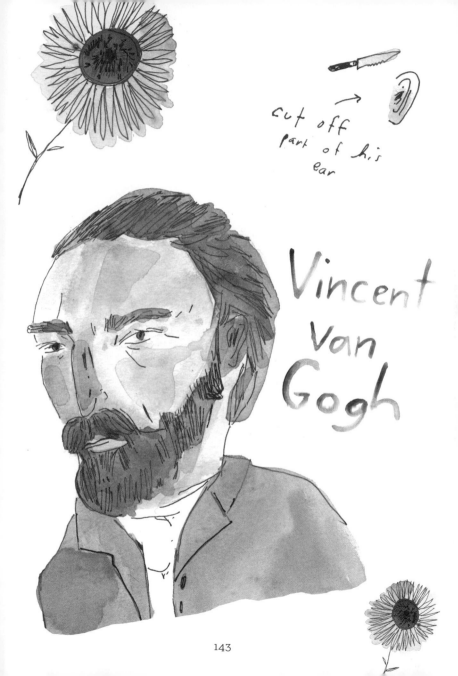

cut off part of his ear

Vincent van Gogh

143

VIVIENNE WESTWOOD

Fashion designer who popularized
punk and new wave designs

The Weasley Family

and occasional redhead J. K. Rowling

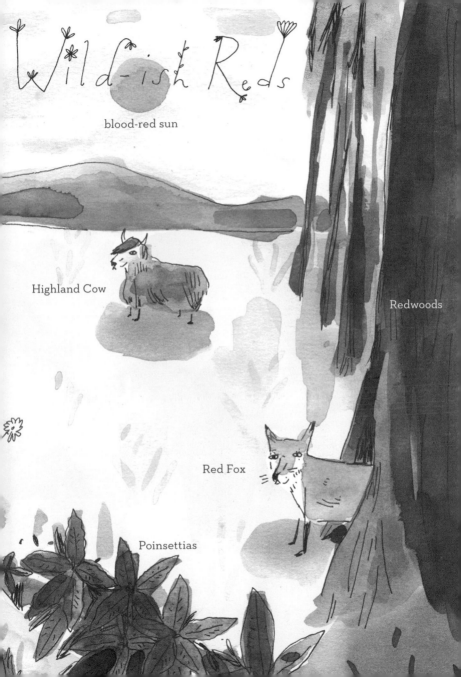

Wild-ish Reds

blood-red sun

Highland Cow

Redwoods

Red Fox

Poinsettias

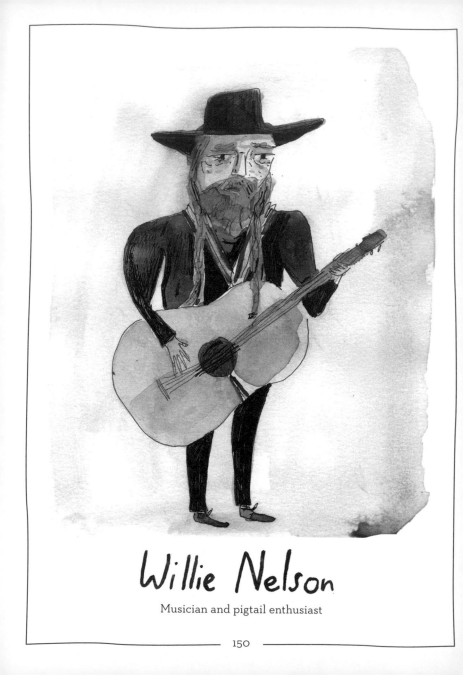

Willie Nelson

Musician and pigtail enthusiast

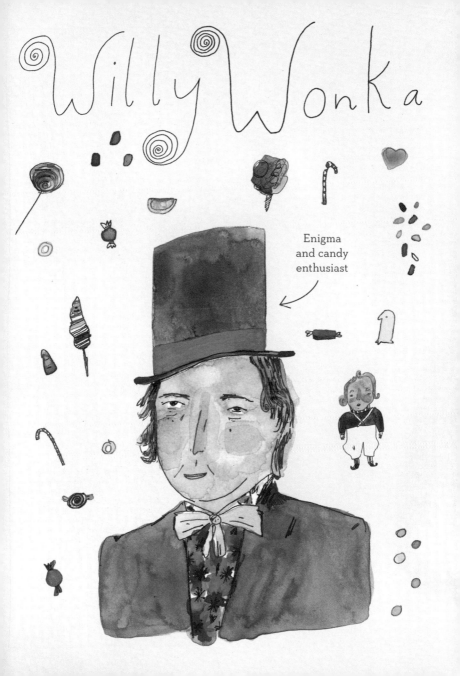

Yosemite Sam

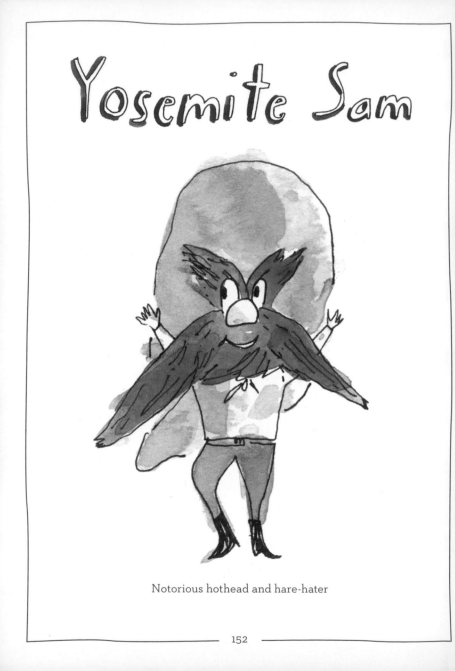

Notorious hothead and hare-hater